A MONTH ON THE RUN

CALENDAR

sun	mon	tue	wed	thur	fri	sat

A collection of my most brilliant thoughts, prolific revelations, random musings, and creative ideas. If found, please return:

..

..

..

..

OPENING REMARKS

Hello,

Although my phone is attached to my hand, in the end, I am a pen and paper girl! I love starting my day with a little inspiration and notes of what I want to accomplish. It was this thought that led me to create a versatile book that was a written house for my life, comprised of inspiration and space to create my daily "to do" lists (when I choose to make one), brilliant thoughts – mine or someone else's, discoveries, notes, and encouragement. Every page has been thoughtfully curated and crafted, giving you a place to host creative mind sessions, plan, dream, record, draw, take notes, learn and be challenged.

Because I'm a girl on the run, I wanted something small and compact that I could easily slip into my bag, so this book has been designed to be just a month at a time.

There are 31 daily pages to accommodate whichever month you choose to start with. On the front cover of the book, you may design and decorate with drawings or words to manifest your dreams. In between the covers, you will take one day at a time, and in the back of the book, you will find extra pages to take notes, weekly pages to set your intention and list action steps to accomplish them (IMAS), recap your month, record expenses and projected income, and find notes of inspirational activities for you to engage in throughout the month.

Enjoy!

XO, Jan

10

> *It takes as much energy to WISH as it does to PLAN.* ELEANOR ROOSEVELT

PUT YOUR PLAN TOGETHER, EVEN IF IT'S JUST A SIMPLE PLAN, & THEN...

TAKE ACTION

Brilliant wishes & plans:

3 ACTION STEPS

02

SERVICE REQUIRED	MARK HERE
NIGHT LETTER	
DAY LETTER	
FAST MESSAGE	

TELEGRAM

GREAT NORTHERN

TIME FILED

YOUR TIME IS LIMITED, SO DON'T WASTE IT LIVING SOMEONE ELSE'S LIFE. DON'T BE TRAPPED BY DOGMA — WHICH IS LIVING WITH THE RESULTS OF OTHER PEOPLE'S THINKING. DON'T LET THE NOISE OF OTHER'S OPINIONS DROWN OUT YOUR OWN INNER VOICE. AND MOST IMPORTANT, HAVE THE COURAGE TO FOLLOW YOUR HEART AND INTUITION. THEY SOMEHOW ALREADY KNOW WHAT YOU TRULY WANT TO BECOME. EVERYTHING ELSE IS SECONDARY.
— STEVE JOBS

RESPONSE REQUESTED

03

ELEUTHEROMANIA

(n.) eleutheromania: an intense and irresistible desire for *free*

04

down

> "How very little can be done under the spirit of fear."
> Florence Nightingale

> I am *NO BIRD;* & *NO NET* ensnares me: I am a *FREE HUMAN BEING* with an *INDEPENDENT WILL.*
>
> —*Charlotte Brontë, Jane Eyre*

05

06

PUSH THE LIMITS

YOU DON'T NEED PERMISSION

07

08

09

The only people for me are the mad ones, the ones who are mad to live, mad to talk, mad to be saved, desirous of everything at the same time, the ones who never yawn or say a commonplace thing, but burn, burn burn like fabulous yellow roman candles exploding like spiders across the stars.
JACK KEROUAC, On the Road

freedom is...

10

II

RULES TO BREAK TODAY

"Whatever you choose, however many roads you travel, I hope that you choose not to be a lady. I hope you will find some way to break the rules and make a little trouble out there. And I also hope that you will choose to make some of that trouble on behalf of women."
—*Nora Ephron*

SHOOT FOR THE

~~STATUS QUO~~ ~~EASY WAY~~
~~LOW-HANGING FRUIT~~
~~PAT ON THE BACK~~ ~~RETIREMENT PLAN~~
~~SAFETY NET~~ ~~MONEY IN THE BANK~~
~~JOB TITLE~~ ~~CORNER OFFICE~~
~~STEADY PAYCHECK~~ ~~RED CARPET~~
~~BOOK DEAL~~ ~~LIFE OF LEISURE~~

MOON

12

13

YOU CAN'T START AT THE BEGINNING IF YOU DON'T KNOW THE END

14

← **THINK FROM THE END.**

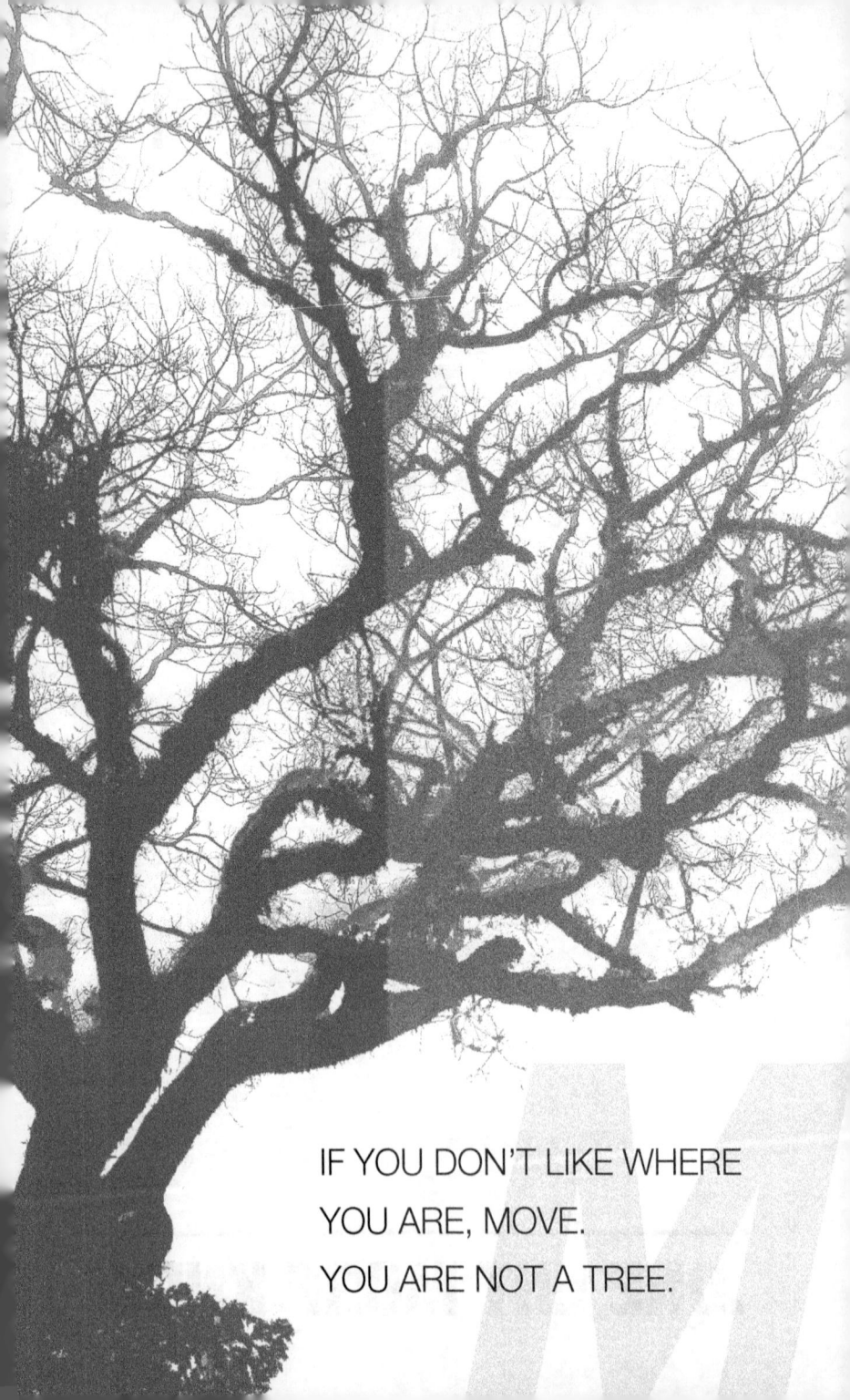

15

16

I BELIEVE I CAN FLY

... AND SO I SHALL

17

If you want something you've never had, you've got to do something you've never done.

18

> To achieve what 1% of the world's population has, (Financial Freedom) you must be willing to do what only 1% dare to do...hard work and perseverance of the highest order."
>
> — Manoj Arora

19

20

PLEASE DON'T FEED THE FEARS

GROWTH IS PAINFUL. CHANGE IS PAINFUL. BUT **NOTHING** IS AS PAINFUL AS STAYING ~~STUCK~~ SOMEWHERE YOU DON'T BELONG.

21

I START WITH A BLANK CANVAS

22

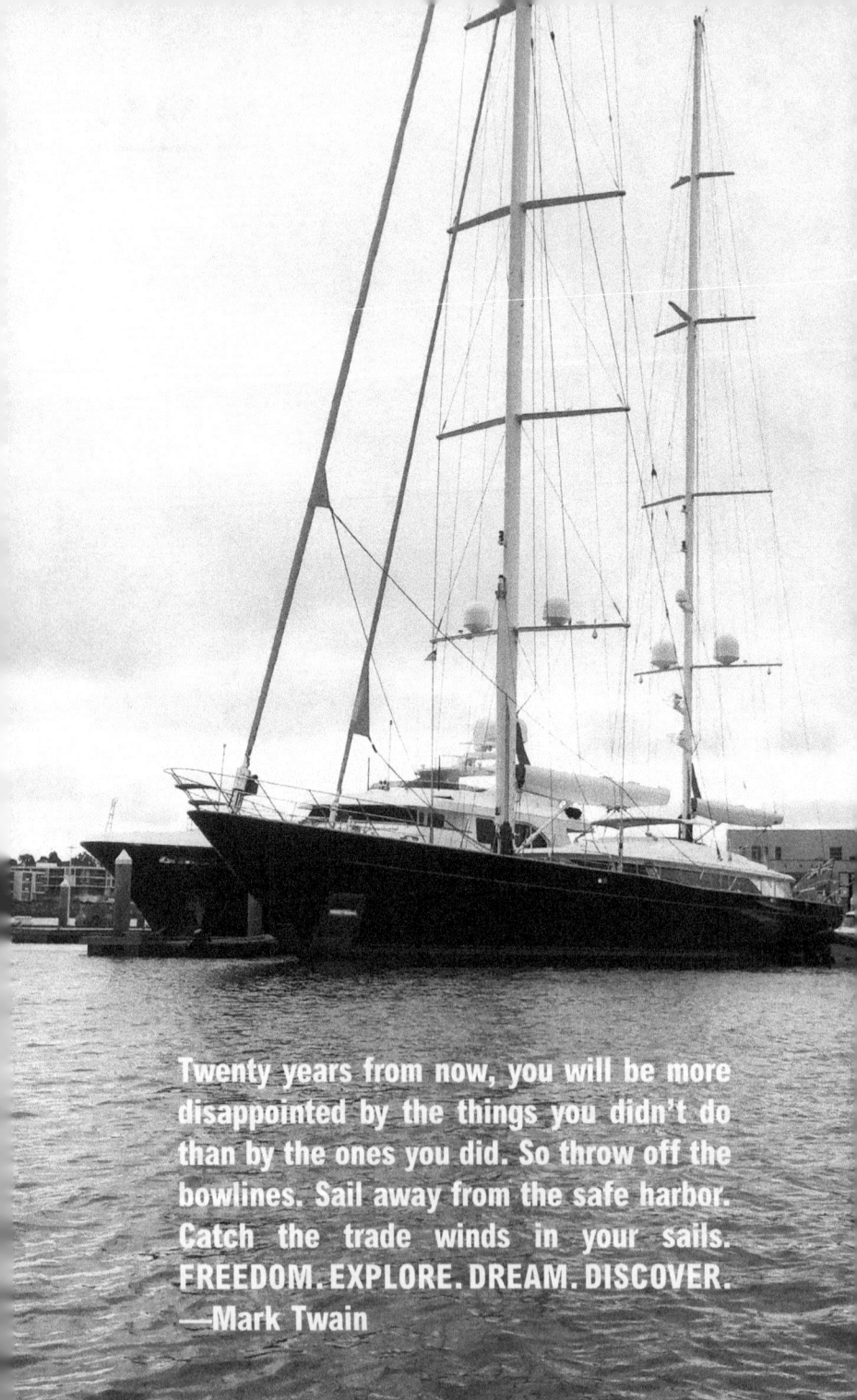

23

24

There is freedom in thinking outside the box, going off the beaten path, and coloring outside the lines.

DOODLING FREES YOUR CREATIVITY

25

26

FLY YOUR OWN FLAG

draw your flag

27

A golden cage is still a cage

28

barn's burnt down —

now i can see the moon
— mizuta masahide

29

"IMPOSSIBLE IS JUST A BIG WORD THROWN AROUND BY SMALL MEN WHO FIND IT EASIER TO LIVE IN THE WORLD THEY'VE BEEN GIVEN THAN TO EXPLORE THE POWER THEY HAVE TO CHANGE IT. IMPOSSIBLE IS NOT A FACT, IT'S AN OPINION. IMPOSSIBLE IS POTENTIAL. IMPOSSIBLE IS NOT A DECLARATION. IT'S A DARE. IMPOSSIBLE IS POTENTIAL. IMPOSSIBLE IS TEMPORARY. IMPOSSIBLE IS NOTHING."
MOHAMMED ALI

30

Fireflies do it.
Flashlights do it.
You can too.
SHINE YOUR LIGHT!

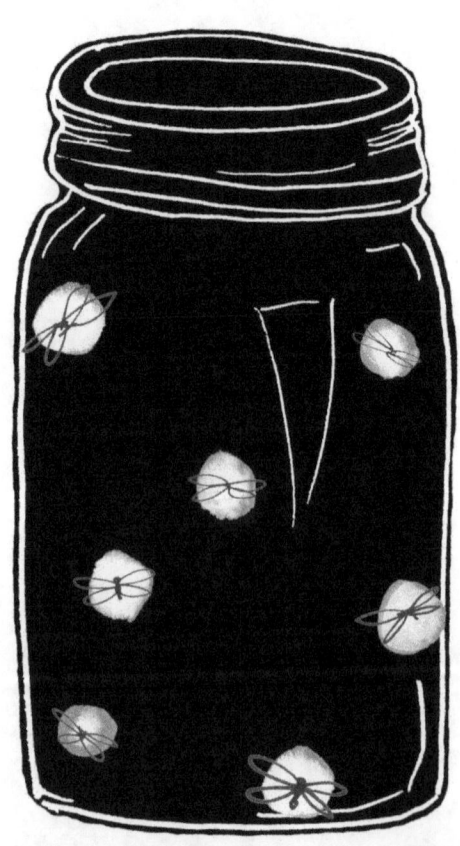

31

Fireflies are ordinary by day,
spectacularly illuminating by night.
That which is within us
illuminates us and those around us.

EXTRACURRICULAR ACTIVITIES

31 THINGS TO DO THIS MONTH

- Get some sunshine, intentional and purposeful
- Hire a stylist (or barter with one) and update your wardrobe
- Visit a local Farmer's Market and document your discoveries
- Walk somewhere fun
- Head to the nearest body of water
- Kick off your shoes
- Find a hammock, a margarita and a good podcast
- Create and finish a DIY project
- Catch the sunrise with a breakfast picnic
- Play croquet
- Go to a concert (outdoor might be nice)
- Take a different route
- Make a new friend
- Go on a road trip
- Find a new coffee shop
- Go somewhere alone- absolutely alone and discover yourself
- Plan a garden/brunch party
- Do a random act of kindness
- Eat cake for breakfast and pretend it's your birthday
- Write a thank-you note to someone random
- Treat yourself to an ice cream, double scoop, new flavor
- Learn something new
- Buy yourself a huge bouquet of flowers
- Get yourself a new piece of jewelry
- Cook a new recipe
- Watch the sunset
- Visit a place you've never been before
- Sing outloud, maybe do a dubmash and post it somewhere
- Dance like no one is watching
- Do something naughty
- Plant something good

IMAS: INTENTION MEETS ACTION = SUCCESS
WEEK OF:
SOMEDAY NEEDS A PLAN

Date:	Write intention + list action steps
MON	
TUE	
WED	
THU	
FRI	
SAT	
SUN	

IMAS: INTENTION MEETS ACTION = SUCCESS
WEEK OF:
SOMEDAY NEEDS A PLAN

Date:	Write intention + list action steps
MON	
TUE	
WED	
THU	
FRI	
SAT	
SUN	

IMAS: INTENTION MEETS ACTION = SUCCESS
WEEK OF:
SOMEDAY NEEDS A PLAN

Date:	Write intention + list action steps
MON	
TUE	
WED	
THU	
FRI	
SAT	
SUN	

IMAS: INTENTION MEETS ACTION = SUCCESS
WEEK OF:
SOMEDAY NEEDS A PLAN

Date:	Write intention + list action steps
MON	
TUE	
WED	
THU	
FRI	
SAT	
SUN	

IMAS: INTENTION MEETS ACTION = SUCCESS
WEEK OF:
SOMEDAY NEEDS A PLAN

Date:	*Write intention + list action steps*
MON	
TUE	
WED	
THU	
FRI	
SAT	
SUN	

EXPENSES

01.
02.
03.
04.
05.
06.
07.
08.
09.
10.
11.
12.
13.
14.
15.
16.
17.
18.
19.
20.
21.
22.
23.
24.
25.
26.
27.
28.
29.
30.
31.

PROJECTED INCOME

01.
02.
03.
04.
05.
06.
07.
08.
09.
10.
11.
12.
13.
14.
15.
16.
17.
18.
19.
20.
21.
22.
23.
24.
25.
26.
27.
28.
29.
30.
31.

MONTHLY REFLECTIONS

Where are you [mentally] this month, what did you accomplish, what did you learn, what is still pending, how are you feeling about what is going on?

Take Note(s):

Jan McCarthy | @janmccarthy | www.janmccarthy.com

xo, jan

www.ingramcontent.com/pod-product-compliance
Lightning Source LLC
Chambersburg PA
CBHW061443180526
45170CB00004B/1532